LOVE IS A

COCKAPOO

summersdale

LOVE IS A COCKAPOO

An Hachette UK Company
www.hachette.co.uk

Summersdale Publishers Ltd
Part of Octopus Publishing Group Limited
Carmelite House
50 Victoria Embankment
LONDON
EC4Y 0DZ
UK

www.summersdale.com

Printed and bound in China

ISBN: 978-1-78783-992-2

Substantial discounts on bulk quantities of Summersdale books are available to corporations, professional associations and other organizations. For details contact general enquiries: telephone: +44 (0) 1243 771107 or email: enquiries@summersdale.com.

♥ INTRODUCTION ♥

It's clear to see why cockapoos are so popular – they're super-loyal, super-cute and super-teddy-like. They even have the good manners to be super-hypoallergenic. What more could you want from your fluffy trusty companion? Dive in to these pages for a celebration of these adorable pooches, and see why cockapoos give us oh-so-many reasons to smile.

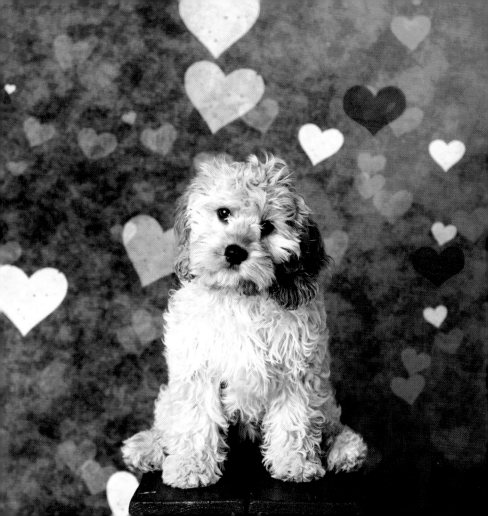

LOVE IS A

♥ FLUFFY ♥

COCKAPOO

WHY DOES WATCHING A DOG BE A DOG FILL ONE WITH HAPPINESS?

Jonathan Safran Foer

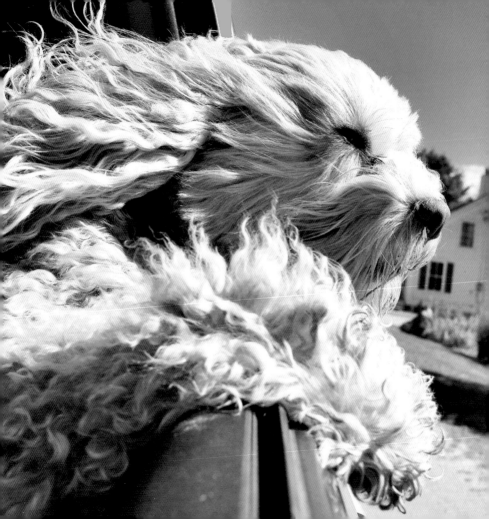

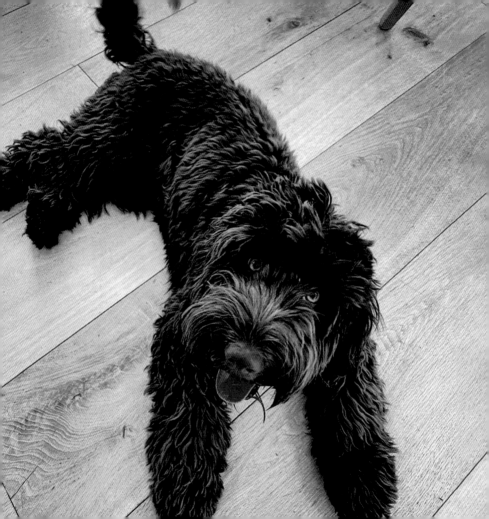

YOU CALLED FOR
TECH SUPPORT?
I'M HERE TO
♥ DELETE ♥

YOUR COOKIES

YOU THINK DOGS WILL NOT BE IN HEAVEN? I TELL YOU, THEY WILL BE LONG BEFORE ANY OF US.

Robert Louis Stevenson

PLEASE,

❤ NO ❤

PUP-ARAZZI

A DOG IS THE ONLY THING ON EARTH THAT LOVES YOU MORE THAN HE LOVES HIMSELF.

Josh Billings

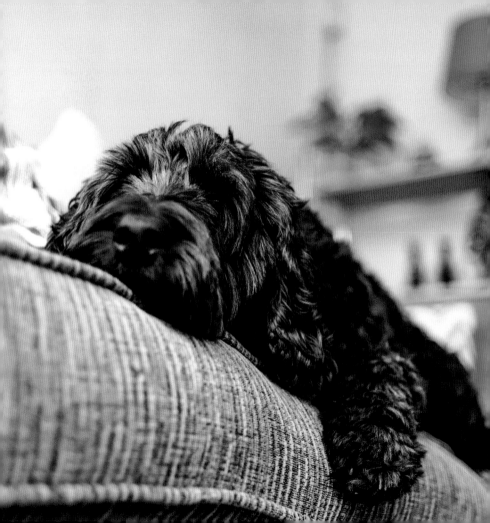

IT'S EXHAUSTING
♥ BEING THIS ♥

ADORABLE

ALL THE TIME

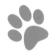

DOG, N. A KIND OF ADDITIONAL OR SUBSIDIARY DEITY DESIGNED TO CATCH THE OVERFLOW AND SURPLUS OF THE WORLD'S WORSHIP.

Ambrose Bierce

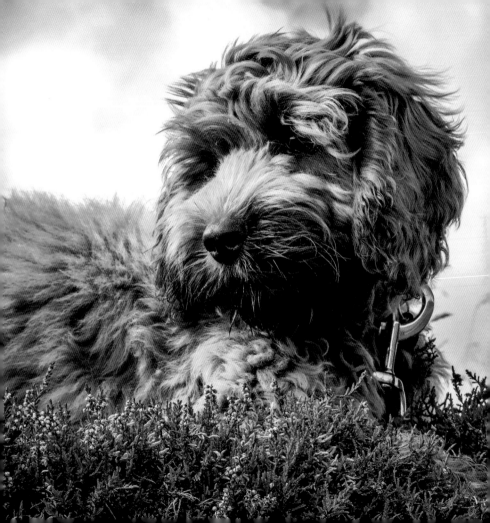

I'VE HAD

♥ A VERY ♥

TIRING DAY

DOGS ARE NOT OUR WHOLE LIFE, BUT THEY MAKE OUR LIVES WHOLE.

Roger Caras

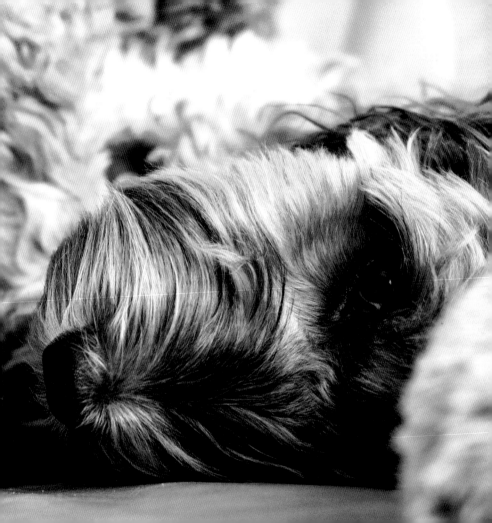

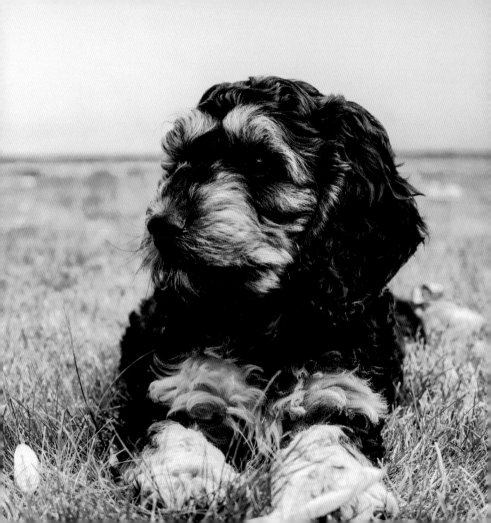

FELT CUTE,

♥ MIGHT ♥

DELETE LATER

THE DOG WAS CREATED SPECIALLY FOR CHILDREN. HE IS THE GOD OF FROLIC.

Henry Ward Beecher

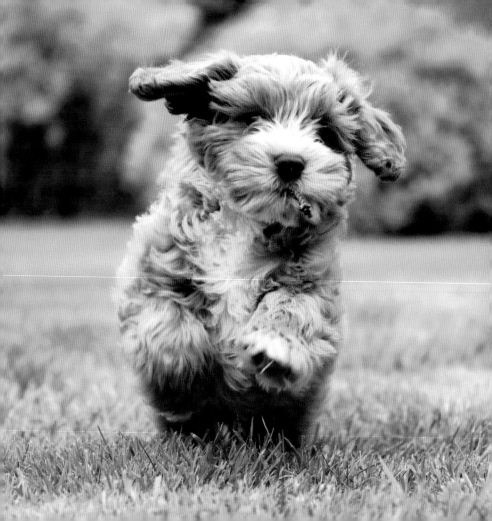

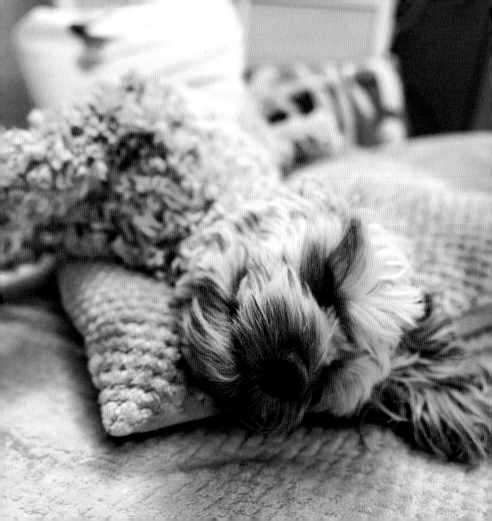

ALL I NEED NOW
IS TUMMY RUBS
♥ AND I'LL BE ♥
IN HEAVEN

A WELL-TRAINED DOG WILL MAKE
NO ATTEMPT TO SHARE YOUR LUNCH.
HE WILL JUST MAKE YOU FEEL SO
GUILTY THAT YOU CANNOT ENJOY IT.

Helen Thomson

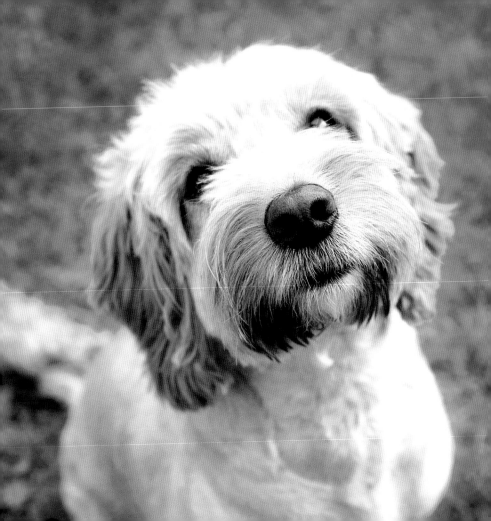

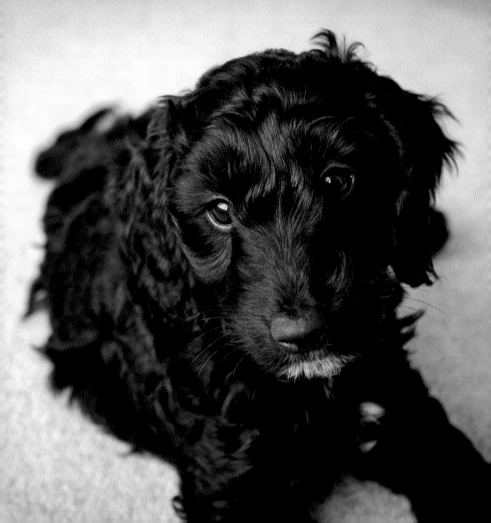

IS IT TIME
♥ TO WATCH ♥

JURASSIC BARK

NOW?

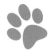

A PUPPY IS BUT A DOG, PLUS HIGH SPIRITS, AND MINUS COMMON SENSE.

Agnes Repplier

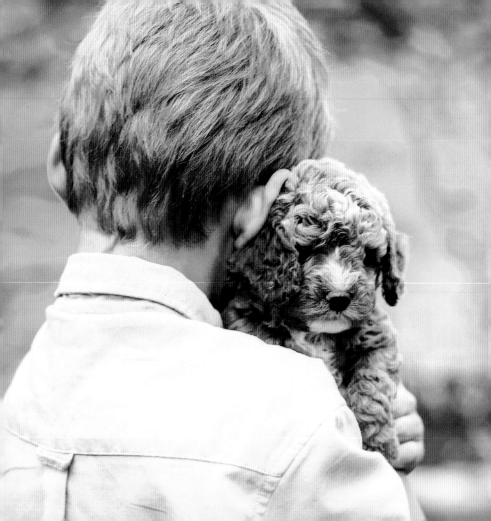

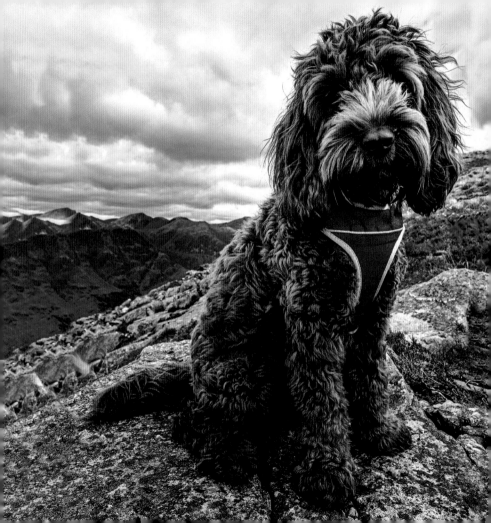

ANYTHING ♥ IS ♥ PAW-SIBLE!

WHOEVER SAID YOU CAN'T BUY HAPPINESS FORGOT LITTLE PUPPIES.

Gene Hill

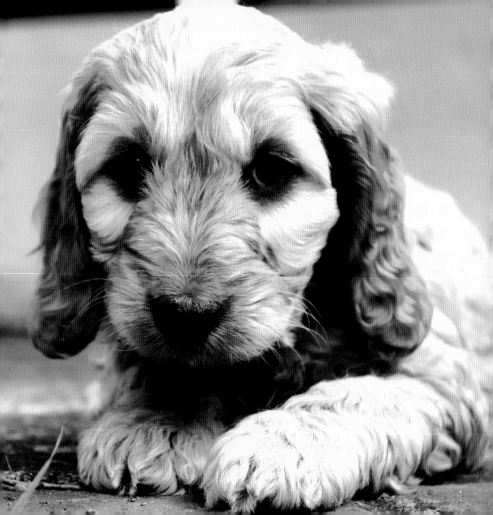

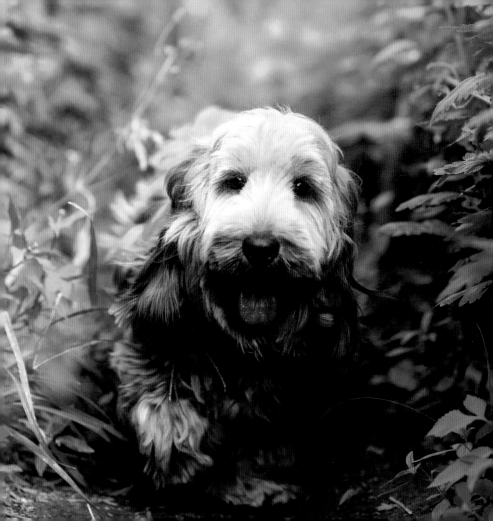

CUTENESS?

♥ I CAN ♥

FETCH

THAT FOR YOU!

I AM I BECAUSE MY LITTLE DOG KNOWS ME.

Gertrude Stein

AND FOR MY
NEXT TRICK I
WILL MAKE THESE
♥ BISCUITS ♥

DISAPPEAR!

THE GIFT WHICH I AM SENDING
YOU IS CALLED A DOG, AND IS
IN FACT THE MOST PRECIOUS AND
VALUABLE POSSESSION OF MANKIND.

Theodorus Gaza

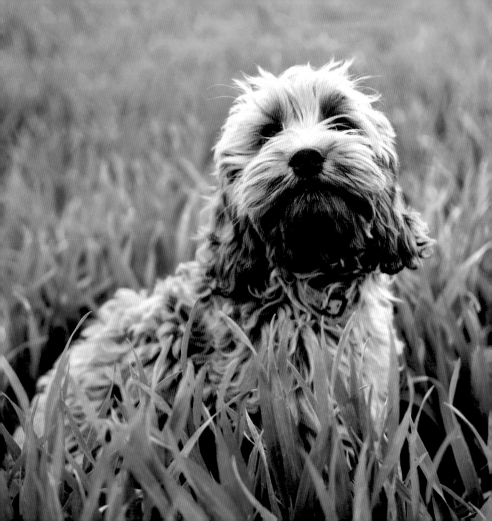

JUST THROW THE

♥ HECKING ♥

BALL!

THE GREAT PLEASURE OF A DOG IS
THAT YOU MAY MAKE A FOOL OF
YOURSELF WITH HIM AND NOT ONLY
WILL HE NOT SCOLD YOU, BUT HE
WILL MAKE A FOOL OF HIMSELF TOO.

Samuel Butler

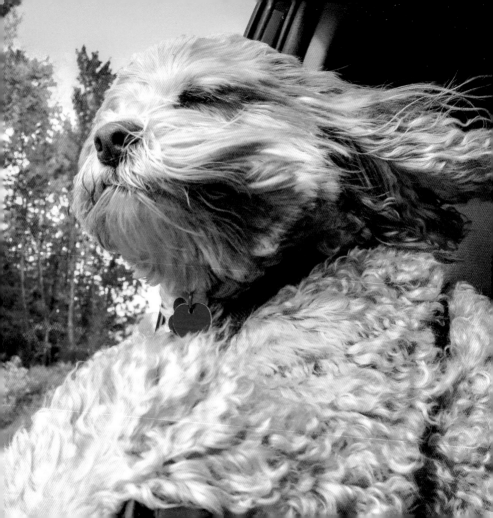

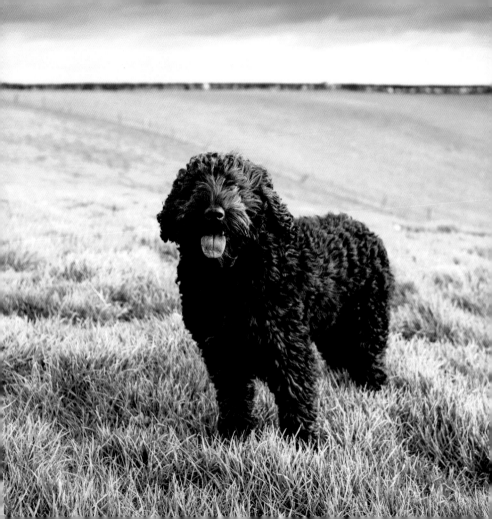

♥ I WOKE ♥

PUP

LIKE THIS

"I'M NOT ALONE,"
SAID THE BOY.
"I'VE GOT A PUPPY."

Jane Thayer

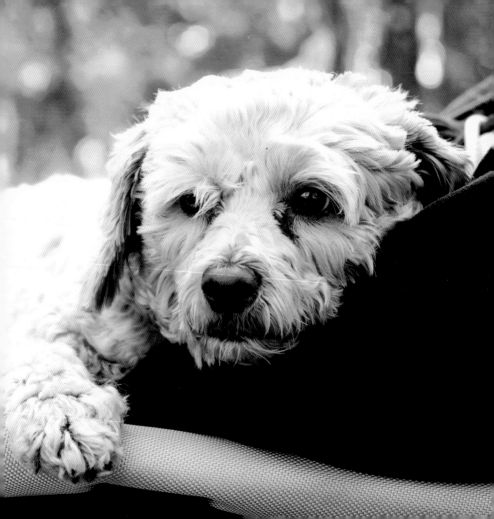

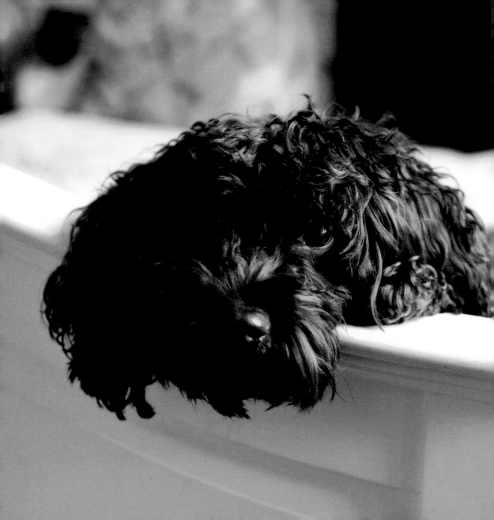

♥ IT'S BEEN A ♥

RUFF DAY

IT'S IMPOSSIBLE TO KEEP A STRAIGHT FACE IN THE PRESENCE OF ONE OR MORE PUPPIES.

Anonymous

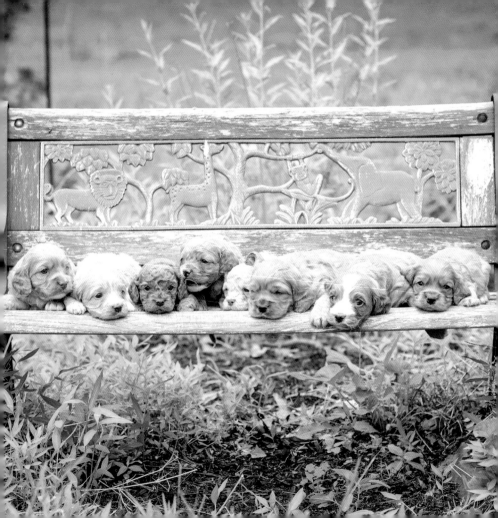

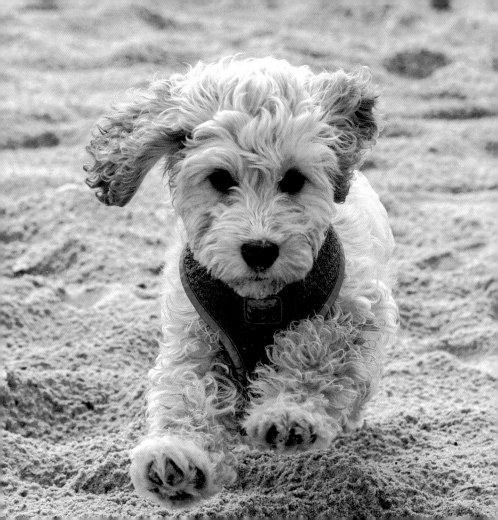

OUTTA MY WAY!
I HEARD THE
♥ FRIDGE ♥

DOOR OPEN!

A DOG IS A BUNDLE OF PURE LOVE, GIFT-WRAPPED IN FUR.

Andrea Lochen

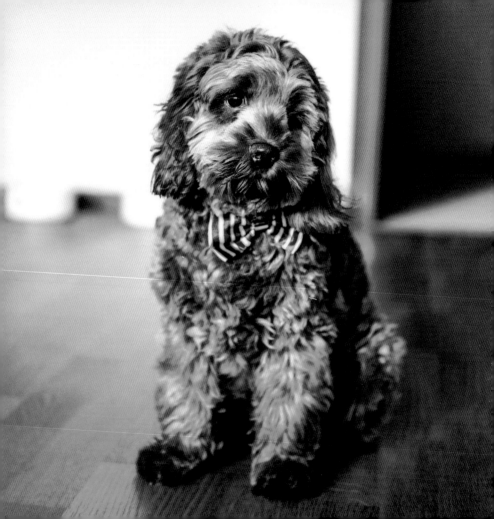

♥ AH, NATURE'S ♥

BLOW DRY!

EVERYTHING I KNOW, I LEARNED FROM DOGS.

Nora Roberts

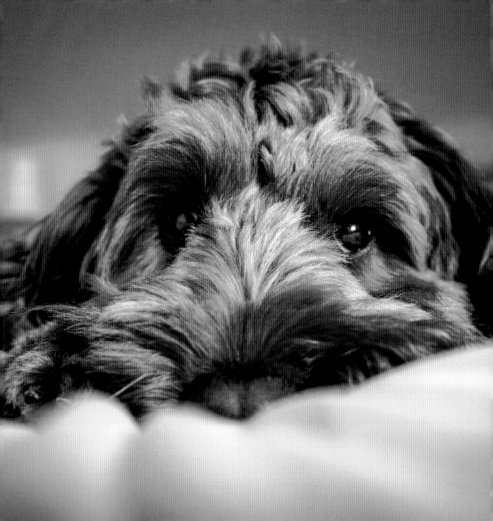

YES, I'M CUTE, BUT IF YOU DON'T STOP BOOPING MY NOSE I'M GOING ♥ TO POOP IN ♥

YOUR BED

FROM THE DOG'S POINT OF VIEW, HIS MASTER IS AN ELONGATED AND ABNORMALLY CUNNING DOG.

Mabel L. Robinson

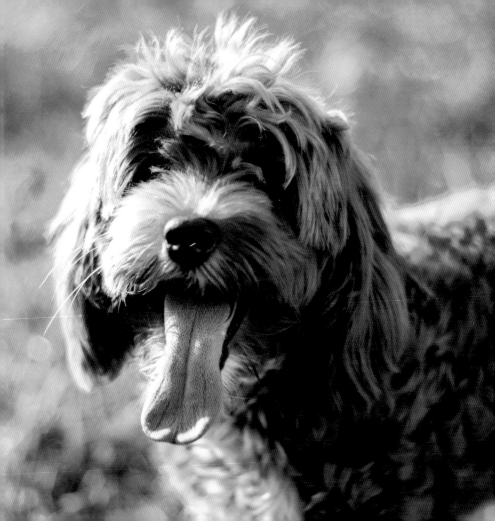

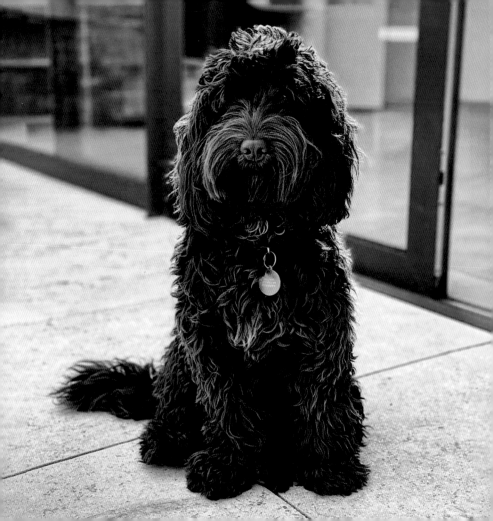

I SAW YOU IN THERE,
PETTING OTHER DOGS.
I'M NOT ANGRY,
♥ I'M JUST ♥

DISAPPOINTED

DOGS FEEL VERY STRONGLY THAT THEY
SHOULD ALWAYS GO WITH YOU IN
THE CAR, IN CASE THE NEED SHOULD
ARISE FOR THEM TO BARK VIOLENTLY
AT NOTHING RIGHT IN YOUR EAR.

Dave Barry

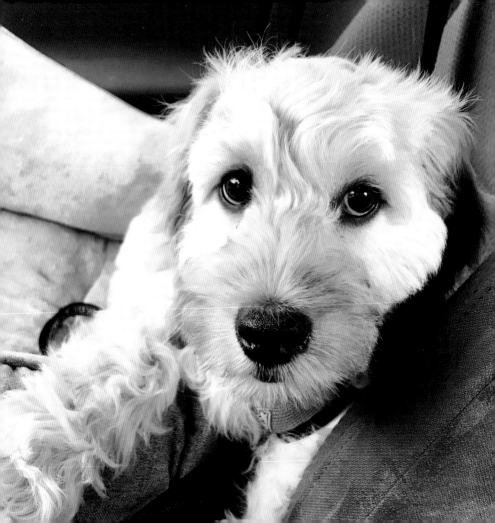

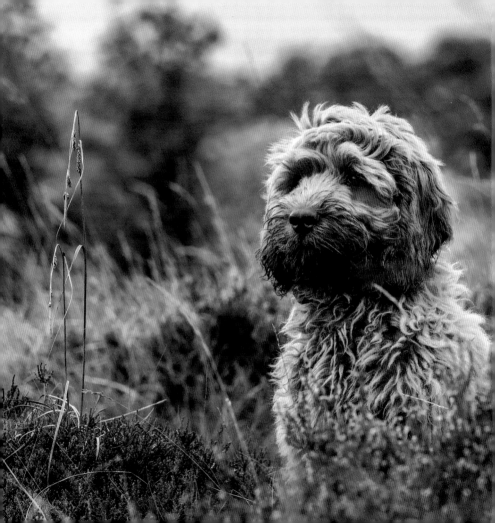

WHAT IF I
NEVER FIND
❤ OUT WHO'S A ❤

GOOD BOY?

NO MATTER HOW LITTLE MONEY OR
HOW FEW POSSESSIONS YOU OWN,
HAVING A DOG MAKES YOU RICH.

Louis Sabin

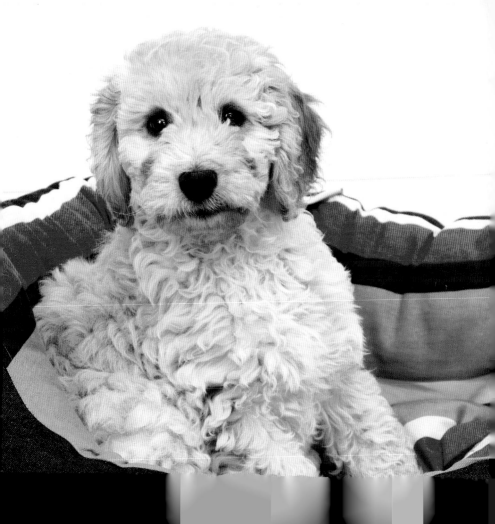

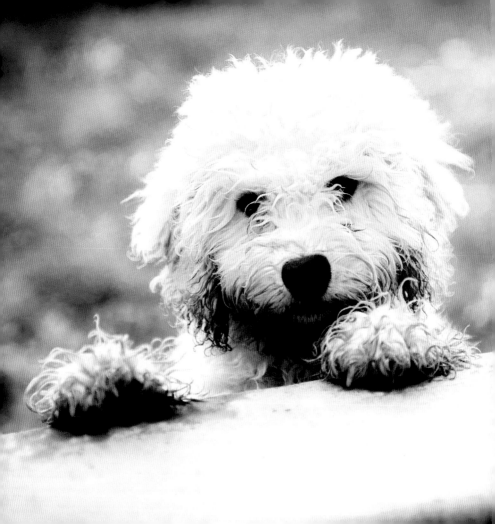

LOST YOUR MOP?

♥ I MAY BE ABLE ♥

TO HELP...

NO ONE APPRECIATES THE VERY SPECIAL GENIUS OF YOUR CONVERSATION AS THE DOG DOES.

Christopher Morley

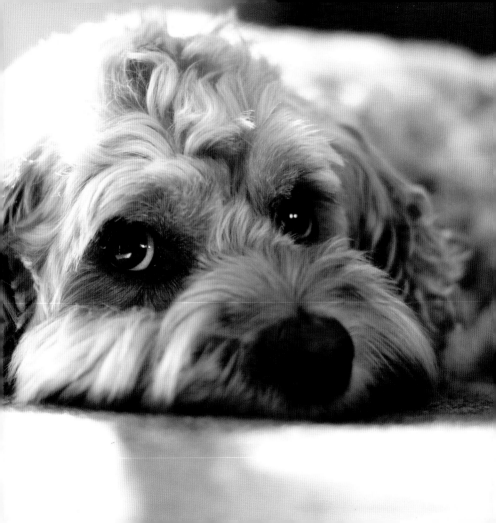

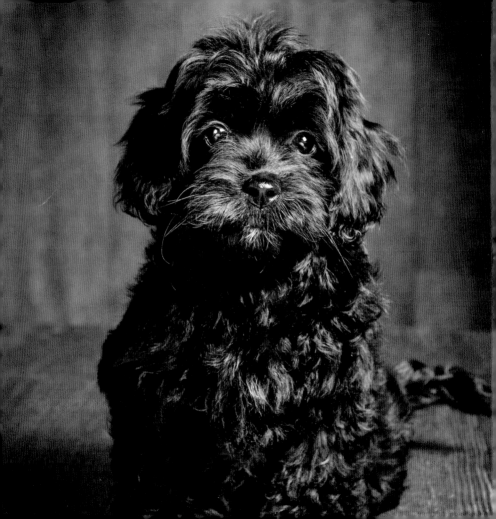

YOU'RE GOING OUT WITHOUT ME? BUT I WANT TO SPEND EVERY ❤ WAKING MINUTE ❤ WITH YOU!

DOGS ARE MIRACLES WITH PAWS.

Susan Ariel Rainbow Kennedy

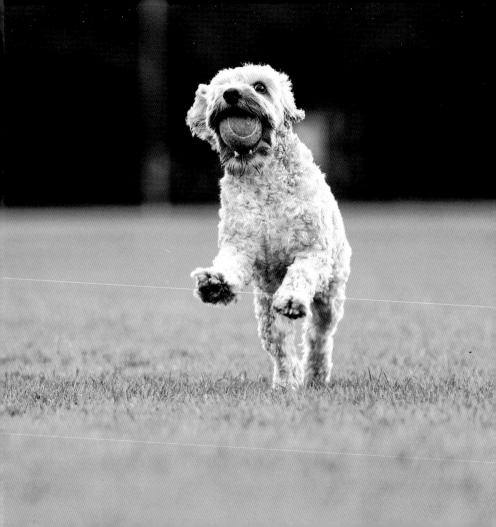

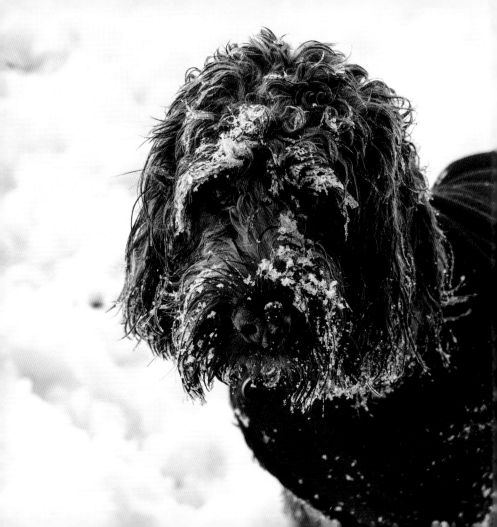

♥ SNOW : 1 ♥

COLIN : 0

THE DOG LIVES FOR THE DAY, THE HOUR, EVEN THE MOMENT.

Robert Falcon Scott

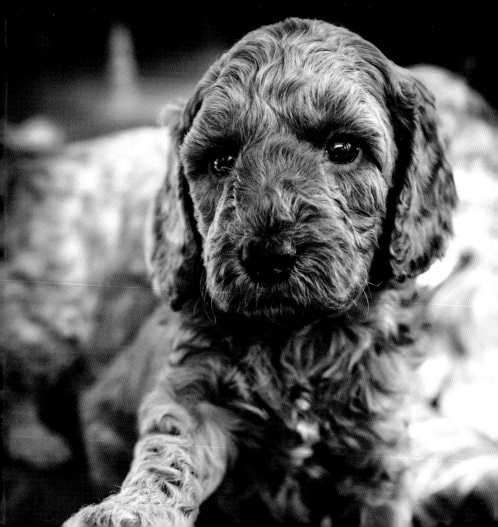

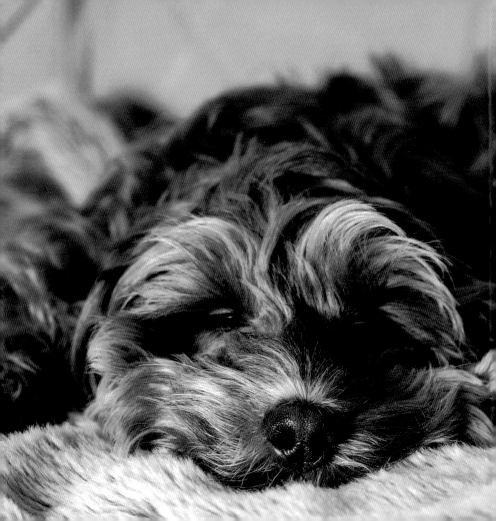

HOME IS
❤ WHERE YOUR ❤

COCKAPOO IS

MY LITTLE DOG —
A HEARTBEAT
AT MY FEET.

Edith Wharton

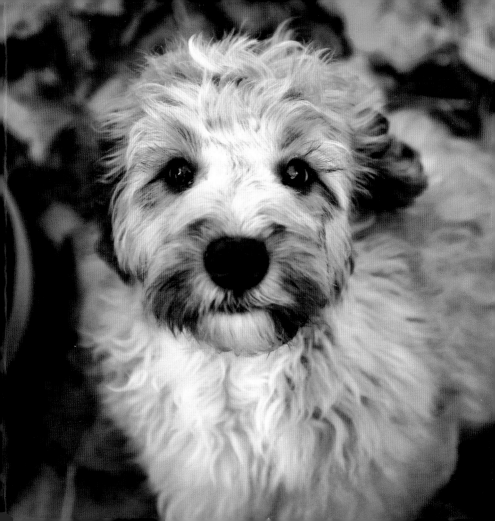

If you're interested in finding out more about our books, find us on Facebook at **Summersdale Publishers**, on Twitter at **@Summersdale** and on Instagram at **@Summersdalebooks**.

www.summersdale.com

IMAGE CREDITS